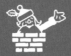
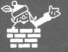

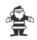

Santa Comes to Town

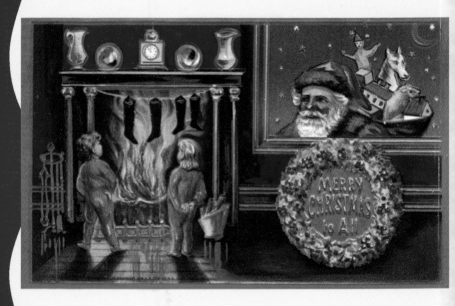

To:

From:

Celebration: Santa Comes to Town

Copyright © Agatha E. Gilmore

978-1-933176-14-7

Published by Red Rock Press
New York, New York

www.redrockpress.com

Library of Congress Cataloging-in-Publication Data

Gilmore, Agatha E.
 Celebration : Santa comes to town / by Agatha E. Gilmore.
 p. cm.
 ISBN 978-1-933176-14-7
 1. Christmas cards. 2. Santa Claus. I. Title.
 NC1866.C5G55 2007
 741.6'84—dc22
 2006100825

Printed in Singapore

for

Tyson,
who keeps me believing

Celebration

Santa Comes to Town

Agatha E. Gilmore

Red Rock Press
New York, New York

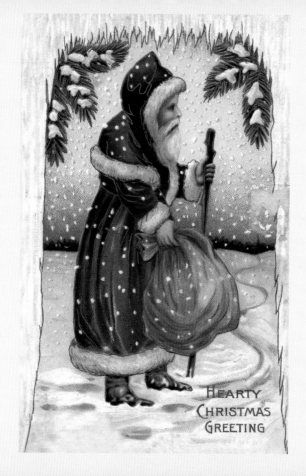

HEARTY
CHRISTMAS
GREETING

Introduction

As you will see in these exquisite greeting cards, Santa Claus has not always been the jolly, red-suited gift-giver we know and love today. In years past, Santa has been tall and thin. He has worn a bishop's hat. He has been a tiny, pointy-eared elf. He has dressed in yellow, green, purple—even black!—robes. In fact, St. Nick meant different things to different people for many years.

Santa's past is storied and vast yet his Christian roots are identifiable. It is widely believed that the legend of a wintertime

9

gift-giver evolved from the story of a fourth-century monk named Nicholas who was known for his kindness towards children. Nicholas was eventually canonized, and December 6th is marked in the Catholic world as St. Nicholas Day. The religious heritage of Santa is why several cards in this collection picture him wearing a bishop's hat.

When Christianity swept across Europe, the winter-solstice celebrations of the late Roman Empire were replaced by the holiday of Christmas. But the clowns who had presided over past winter festivals lent their jolliness to Santa's developing persona.

The heart of St. Nick's character was in place by the time of the Renaissance, when Christmas was widely celebrated. But stiff opposition to holiday festitivities came along with the advent of Puritanism in the 17th century, and Santa's very existence was

jeopardized. In the mid-1600s in England, Christmas festivals and even parties at home were banned. The Puritans objected to both the pagan undertones and the Roman Catholic history of making merry on Christmas. The Puritans approved marking the birth of Christ in a bare church service; nothing touched with gaiety met their standard.

It wasn't until after 1660, with the Restoration (of the monarchy), that the traditional celebration of Christmas became legal again.

Santa was back in action, though he underwent quite a few changes over the next century. His modern identity really cohered in the New World, where many new immigrants brought their native traditions. The Dutch imported their *Sinterklaas*, with his sack of presents and sinister sidekick (Black Peter), to New Amsterdam. German immigrants chimed in with Kris Kringle.

Russian newcomers celebrated Christmas with Ded Moroz ("Grandfather Frost"), who wears a fur-trimmed cloak. And then, on St. Nicholas Day of 1809, Washington Irving published his fanciful *History of New York*, replete with references to a pipe-smoking St. Nick who slid down chimneys.

However, it wasn't until 1822, when Episcopalian minister Clement Clark Moore penned *A Visit from St. Nicholas*—more commonly known by its first line, "Twas the Night Before Christmas"—that Santa's image really solidified. Moore's Santa was rotund, "dressed all in fur, from his head to his foot," and master of a fleet of flying reindeer. The only thing missing was a definitive comment on the color of Santa's robe.

During the Christmas season of 1881, popular American cartoonist Thomas Nast created a corpulent Santa in a striking

crimson robe for *Harper's Weekly*. This image of St. Nick in a fur-trimmed red coat began to overtake other interpretations.

However, the look of Santa was still in flux when he began his frequent appearances on Christmas cards at the turn of the last century.

It's thought that the first Christmas card was commissioned by a busy London museum director named Henry Cole. Too busy to visit or to write individual letters to all of his friends and family, Cole employed a painter named John Callcott Horsely to illustrate a holiday greeting, which Cole then had engraved, printed and delivered to hundreds of his acquaintances.

Greeting cards proved especially useful for those who were either separated from family or on the move. British families

dispersed by imperial-era obligations, and far-flung North American families in different parts of their huge nations, found Christmas cards particularly convenient.

Many early, commercially-manufactured cards (and most in this international collection) were postcards. And while use first boomed among English speakers, holiday cards soon

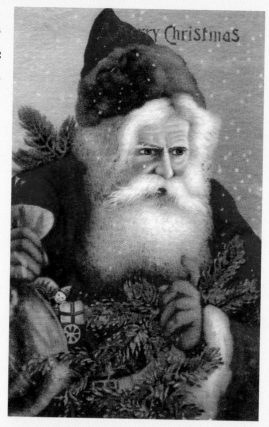

became popular throughout Europe, with a large percentage of card production for use in many nations coming from Germany, particularly Bavaria.

By the early 20th century, a white-bearded Santa Claus was the most popular image on Christmas cards, regardless of where they originated. The cards in this collection come from around the world, and each is unique in its beauty and local flavor. You'll see a blue-robed Santa astride a donkey on an old American card. Another image, printed in Germany, has Santa in red on a bicycle. But above all, in this collection you'll see revelations of Santa's rich past. I hope you take pleasure in these Christmas treasures.

—Aggie Gilmore
Chicago

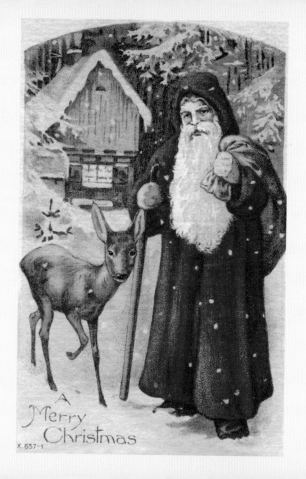

A Merry Christmas

X. 657-1

Table of Contents

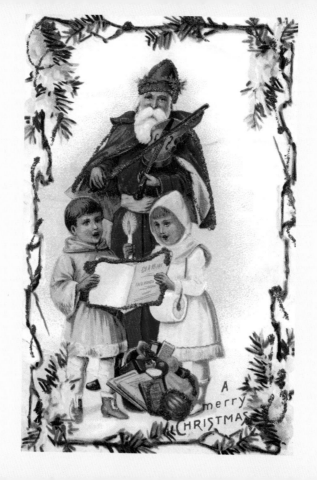

A merry CHRISTMAS

Chapter One

What's in St. Nick's Wardrobe?

Santa Claus has worn many hats—literally!

In some cards, St. Nick dons a bishop's hat, like the red one emblazoned with a white cross in an Austrian card from the early 20th century.

In an American card of the same period, a lean Santa wears a brown-and-white bishop's hat and balances a traditional religious staff in the crook of his arm as he fishes around in his gift sack.

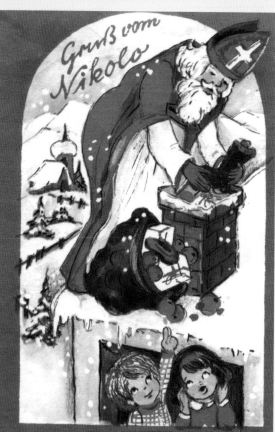

Gruß vom Nikolo

IHR BRAVEN KINDER GEBT JETZT ACHT -
NIKOLAUS EUCH HEUT' GECHENKE MACHT!

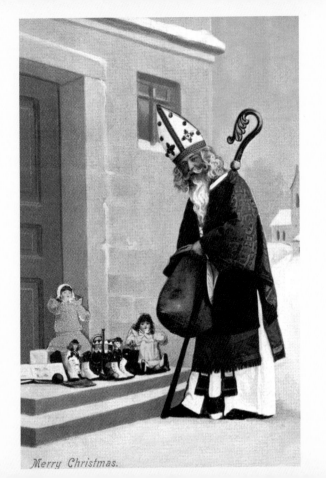

Merry Christmas.

The wintertime gift-giver has also been depicted wearing exotic headgear. In one Swedish card, *Jultomten* (as Santa is known in Sweden) wears a red bouffant cap trimmed with brown to match his robe. The card bids the reader "God Jul!", or "Merry Christmas!"

Mischievous forest-dwelling gnomes have long populated

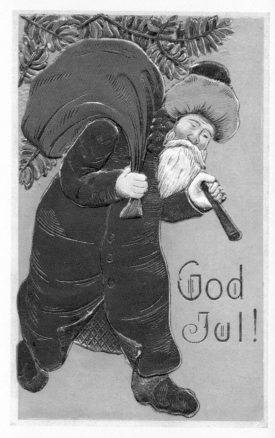

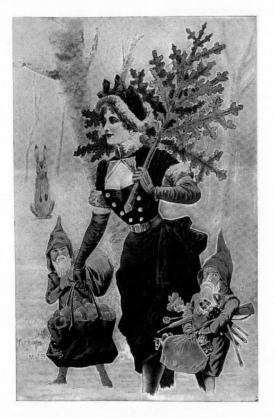

Scandinavian legend. These temperamental figures were tiny with pointed ears and matching pointed shoes, and they interfered in human daily life, for good and for ill. By the nineteenth-century, the elves

This lovely lady in black, trimmed by white fur, might be Mrs. Santa Claus in this old Finnish card.

had become associated with Christmas in some stories where their helpfulness was in the ascendancy. And so it is, that some early Swedish and Finnish Christmas cards depict St. Nick as an elf himself or surrounded by elves. The elves preceded the idea that

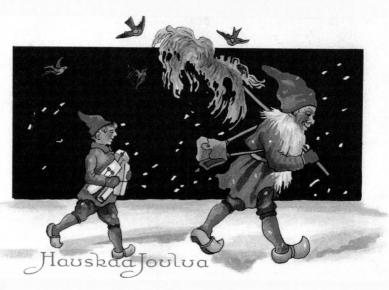

Hauskaa Joulua

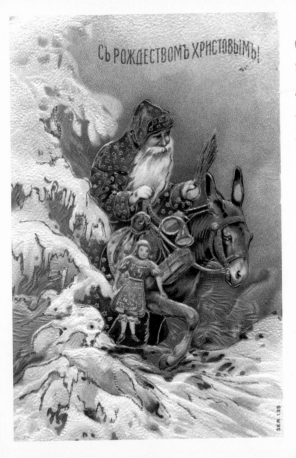

Съ РОЖДЕСТВОМЪ ХРИСТОВЫМЪ!

there was a Mrs. Santa Claus, but after she arrived, they helped her, too.

In one Finnish card from 1922, a small blue "Santa" wears a pointed red hat, matching red stockings and yellow wooden clogs and is closely followed by a still-smaller elfin figure.

25

In other cards in this collection, Santa's hat is actually a hood attached to his robe. In a Russian card from 1905 (previous page), Father Frost wears a red, head-covering cloak embroidered with gold detailing.

An American card shows Santa pretty in pink. Another features Santa in a white hood. A German card of the same period shows Herr Claus in a

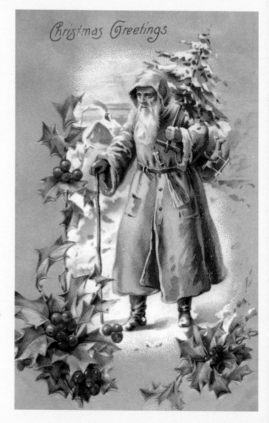

Christmas Greetings

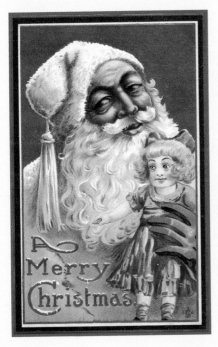

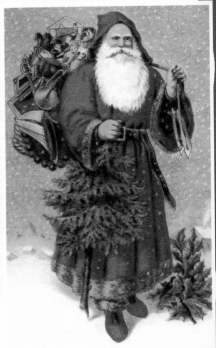

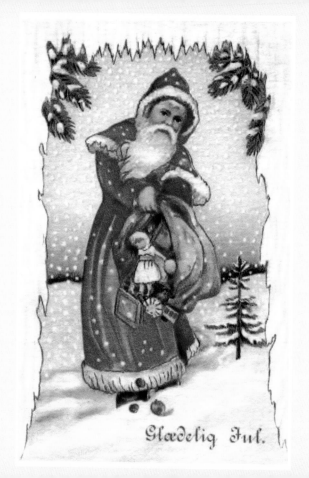

Glædelig Jul.

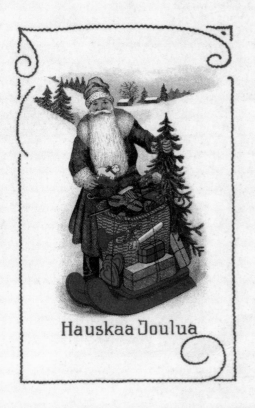

Hauskaa Joulua

simple, belted red "hoodie," albeit with matching red shoes. A Danish card maintains the hood, but shows it trimmed in white fur to match the edge of the cape portion of Santa's robe as well as its bottom.

Whatever hat he wore, Santa usually matched it to the color and design of his robe.

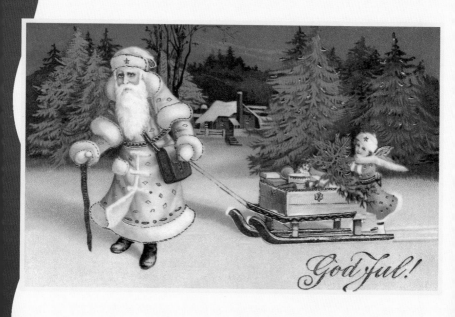

God ful!

In a most basic way, of course, the cut of Santa's clothing has
not only been a reflection of the time and place but of the very

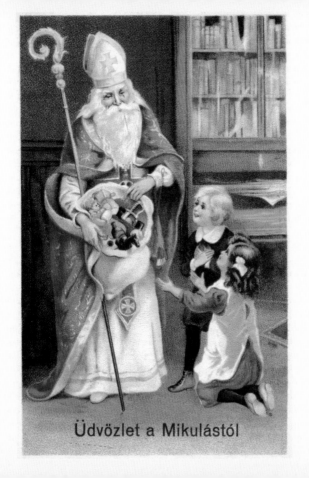

Üdvözlet a Mikulástól

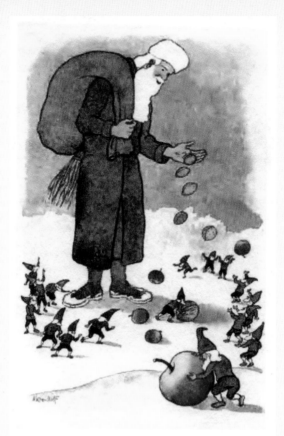

measure of the man.

And what actually is Santa's measure? St. Nicholas didn't start out plump! The tall, thin Santas in some of these cards are probably a tribute to his monk origins. When St. Nick peers out from under a bishop's hat, he is suitably and humbly lean.

Father Christmas is also fit in some early cards where he is not in religious garb.

St. Nick was not fashionably fat until Clement C. Moore wrote *A Visit from St. Nicholas* in 1822. The poem, which received much attention, referred to Santa as "chubby and plump" with "a little round belly / That shook, when he laughed, like a bowlful of jelly."

7010

May everything
that makes for
a happy Xmas
come to you

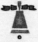

Moore also referred to Santa's pipe-smoking, which Washington Irving attributed to *Sinterklaas* in his 1809 publication of *History of New York*.

Moore cemented both Santa's rotundity and penchant for tobacco in popular imagination. Only in recent years has Santa lost his pipe, a casualty of a health-conscious era. But, so far, Santa remains attired in a (necessarily large) robe.

Although that robe has been red for many decades now, the old cards here allow him to cloak himself in almost any color of the spectrum.

It was not until the 1890s, when the revered American illustrator, Thomas Nast, dressed Santa in a fur-trimmed *crimson*

Santa Claus by Thomas Nash

coat, that red became his signature color. Some historians contend that the red is meant to recall Santa's religious origins, while others suggest that it was the legend of Russia's Ded Moroz—who always wears the color—that influenced Nast's perception. Then, of course, there's always the possibility that Santa just looked peachy in cherry! Whatever the reason, crimson caught on and Santa's trademark look was complete.

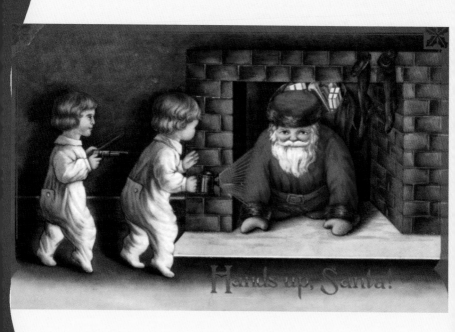

Hands up, Santa!

Chapter Two

Santa Claus—Every Child's Hero!

Santa Claus's longstanding occupation is being kind to
children. In France, *les enfants* keep an eye out for *Père Noël*,
who comes bearing presents on St. Nicholas Day and again on
Christmas Day. The Dutch, Germans and several other nation-
alities on the European continent, as well as English-speaking
youngsters around the globe, know Santa as a gift-giver. They
may also think of him as captain of the biggest toy manufactory in
the northern hemisphere or the world! And, of course, many

children delightfully
believe that "Santa
Claus/North Pole"
suffices as a wish-
list address—which,
more often than not,
thanks to the good
graces of postal
authorities, it does!

Yet Santa is not
the only legendary
Yuletide delivery
person. In
Switzerland, chil-
dren await the

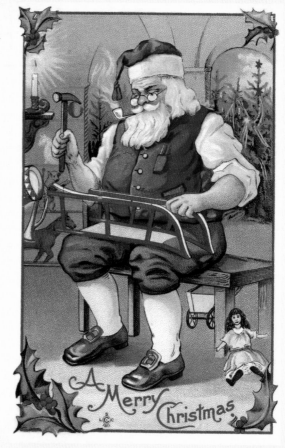

A Merry Christmas

Christkindl, which translates literally as "Christ child." In some Swiss towns, the *Christkindl* is a girl-angel who comes down from heaven bearing gifts. In Spain, Puerto Rico, Mexico and in many South American locales, kids believe that presents are bestowed by a three-person team known as the Three Kings.

Nicholas of Patara was born nearly 300 years after Jesus. The main legend concerning his gift-giving starts with the story of an impoverished father of three young women. Unable to marry his daughters off without dowries, or to support them through another winter, the wretched father contemplated selling them into prostitution or slavery. One dreary evening, two sisters placed their wet shoes by the fireplace while the third draped her stockings over the mantelpiece. It is said that on that night of such cruel prospects, an undetected Nicholas stopped in and left gold coins in the girls' footwear.

This legend has variations but it's most likely the inspiration for Santa's celebrated toy sack, which brims with gifts and sweets for well-behaved children. In an English card from 1905, a midnight-blue-coated Father Christmas smiles goodheartedly, opening his bag of presents to display all the hidden treasures.

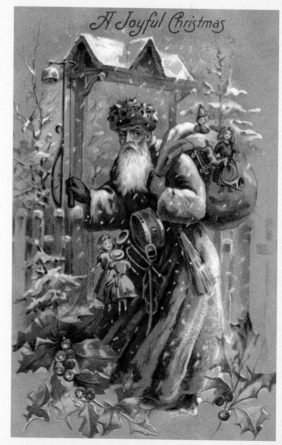

A Joyful Christmas

Christmas Greetings

all for you. Bau.

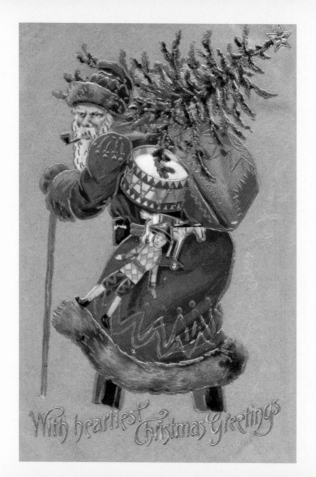

With heartiest Christmas Greetings

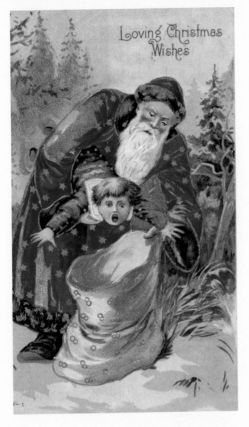

Loving Christmas Wishes

In some countries, Santa has a dark side—in the form of evil assistants. In Holland, *Sinterklaas* travels with a man named Black Peter, who consults *Sinterklaas*'s list and smuggles those marked "naughty" into a sack, never to be seen again. There are antique cards from other countries, however, that show Santa Claus, himself, doing the same deed.

In Germany, *Kris Kringle* travels with a helper known as *Knecht Ruprecht*, *Krampus*, or *Pelzebock*, who punishes the naughty children with a few smacks of his rod.

The sinister-sidekick myth probably inspired the black-coated Santa from the 1910 American card, who frowns angrily as he carries away one crying baby in a basket on his back and grips another frightened-looking child.

This dark undertone might have made children tremble when they heard the lyrics written in 1932 by Haven Gillespie and J. Fred Coots:

> *He's making a list*
> *And checking it twice;*
> *Gonna find out who's naughty and nice . . .*

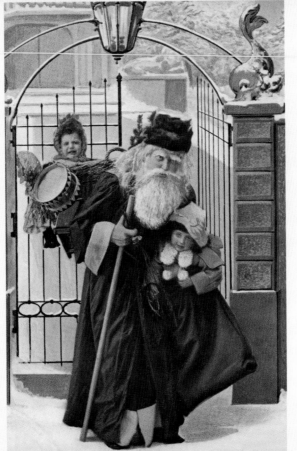

Christmas Greetings!

47

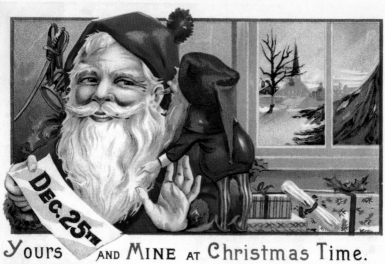

Yours AND MINE AT Christmas Time.

Less than a hundred years ago, the news that Santa was headed to town might have frightened some youngsters.

Much more commonly, however, it was the best news ever.

But before Santa Claus can bestow presents on deserving children, he may wish to know what they'd like to receive. In Finland, where Santa has long had helper elves, Santa (and his wife) are said to live at the top of Korvatunturi, a secret mountain equipped with giant "ears" that can "hear" the wishes of all children. In a card printed in the United States in the 1920s, Santa bends over to listen as a little elf whispers into his ear—presumably telling the great gift-giver what the world's children desire, or perhaps just relaying the wish of a particular tyke.

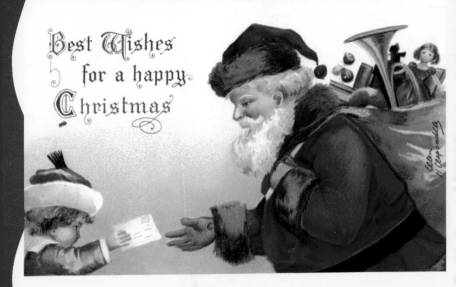

Best Wishes
for a happy
Christmas

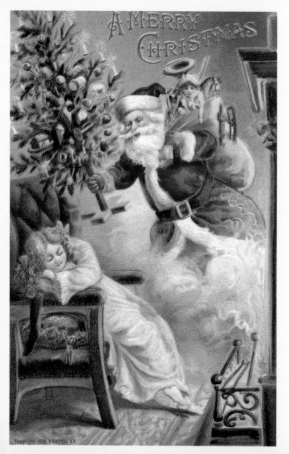

Where there are no magic ears, letters and lists can take their place. One card here depicts a young child handing a letter to St. Nick. Santa's already on his delivery route—with his sack of toys slung over his shoulder—but let us assume this young hopeful has caught St. Nick in the nick of time.

For all his hard work, Santa is treated to a late-night snack at many homes. In North America, it is customary for kids to lay out cookies and milk for Santa's enjoyment. It's not clear how this practice originated, but the logic behind it is that Santa must be tired and hungry from all his nighttime activity. The tradition teaches children to recognize and repay good deeds.

Some cynics may attribute Santa's girth to all those sugary nocturnal snacks but I, for one, hope Santa Claus eludes the food police.

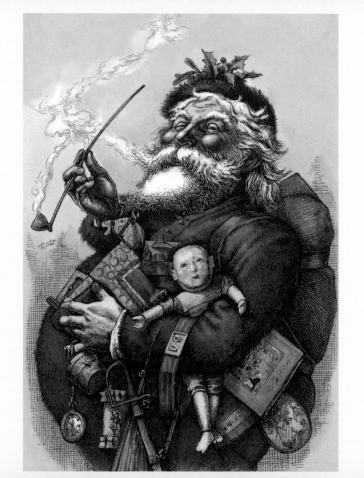

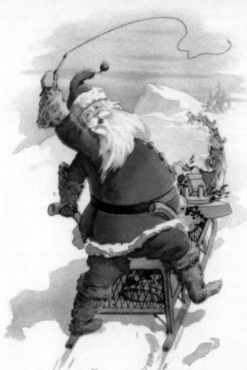

Santa Claus' sleighbells
Ring a silver chime,
May they bring you all you wish
This Merry Christmastime.

Chapter Three

Before and Beyond
Flying Reindeer

Santa didn't always—and still doesn't always—travel by sleigh. True to his eclectic origins, he has been conveyed in a variety of ways both throughout the years and across continents.

Some historians trace his starry-sky passages to the Norse god *Wodan* (or *Odin*), who was believed to fly through the sky at night, accompanied by a black raven, determining the fates of the people below.

Sky travel on a reindeer-drawn sleigh was not Santa's primary mode of getting about on Christmas Eve before Clement Clark Moore's 1823 publication of *A Visit From St. Nicholas.* Eight reindeer (whose names many children know) pulled that legendary sleigh: Dasher, Dancer, Prancer, Vixen, Comet, Cupid, Donner and Blitzen.

More than a century later, in 1939, Robert L. May added famously red-nosed Rudolph as a promotional tool for Montgomery Ward department stores. In 1949, a friend of May's named Johnny Marks catapulted Rudolph into the limelight with his popular song, "Rudolph, the Red-Nosed Reindeer"—and made the glowing addition to Santa's sleigh forever memorable to American children.

Cards in this chapter show Santa trudging along in snowshoes or traveling astride a polar bear.

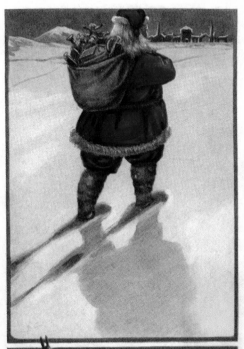

May you Join Santa Claus
in having a good time
this Christmas ✦ ✦ ✦ ✦

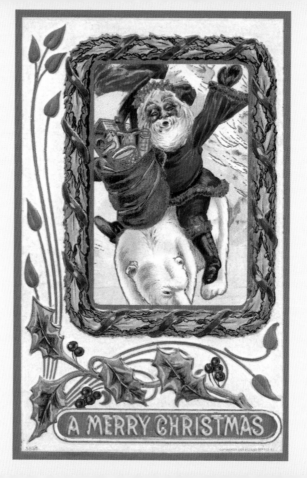

A MERRY CHRISTMAS

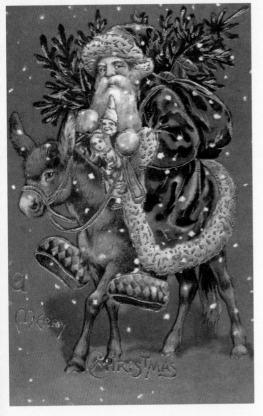

In Russia, Father Christmas usually plowed through the snow on a donkey. Greeting card artists of other nations, including American illustrators, have also shown Santa atop a donkey. In western Europe, Santa was often pictured on foot.

Good old St. Nick, in some instances, has benefited from the

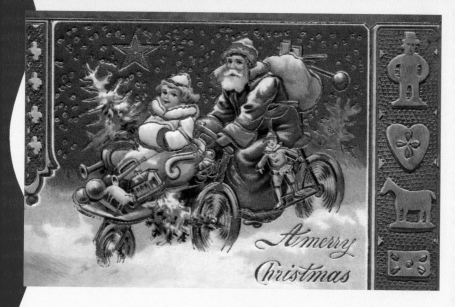

transportation modes of modern living. So after the bicycle was invented in the 19th century, Mr. Claus tried one out. In an especially lovely German-made card, we see Santa, with gift-sack on his back, merrily peddling a bicycle, front-loaded with a sweet-looking little girl and yet more toys.

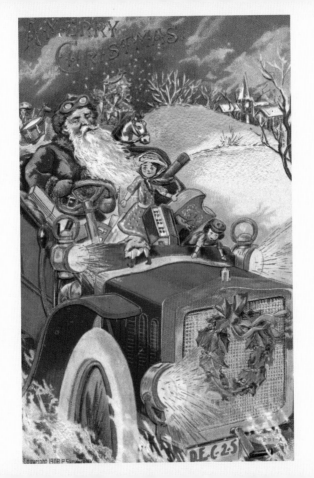

A MERRY CHRISTMAS

Copyright 1908 P. Sander N.Y.

DEC-25

Santa has plumped himself in the driver's or pilot's seat. Yet even if future Christmas cards were to show St. Nick rocketing from planet to planet via the latest inter-galactic spaceship, I have no doubt that some children will continue to keep an eye out for flying reindeer or strain to hear the tinkle of sleigh bells, and the pitter-patter of hooves on their rooftops.

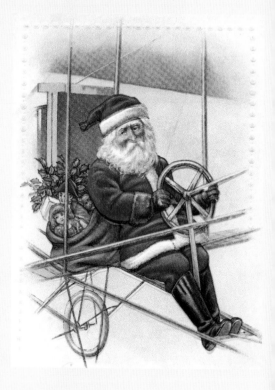

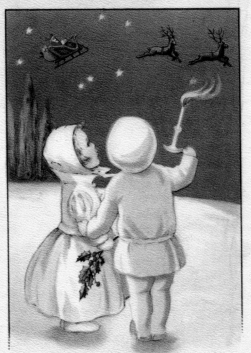

A HAPPY CHRISTMAS

These little tots woke on Christmas Day
And hustled out of their beds
And Lo! and Behold! when they looked up they saw
Old Santa-right over their heads.

63

Credits

Cover: Gilded and embossed; p. 2: Embossed, posted in Mount Horeb, Wisconsin, 1909; p. 8: Embossed, designed by Davidson Bros. of London & New York, printed in Germany; p. 14: Printed in Germany; p. 16: Germany; p. 18: Embossed, printed in Germany, used in Ohio, 1909; p. 20: Made in Austria; p. 21: Printed in Germany, posted in Coney Island, N.Y.C.; p. 22: Embossed and gilded, Sweden; p: 24: Finland, 1922; p. 25: Embossed and gilded, Russia; p. 26: Silvered, U.S.; p. 27 (left): Embossed and gilded, posted in Pittsburgh, 1911; (right): Printed in Germany; p. 28: Denmark; p. 29: Finland; p. 30: Gilded, Norway; p. 31: Printed in Germany for use in Hungary; p. 32: Printed in Germany; p. 34: S. Bergman of New York, 1912; p: 36: Printed in Germany; p: 38: Embossed, Whitney Made, Worcester, Massachusetts.; p. 40: Gilded and embossed; p. 42: Embossed and printed in Germany; p. 43: Embossed, Artistic Series trademark, London, printed in Germany, used in New Jersey; p. 44: Embossed and gilded, printed in Germany, posted in Atlanta, Georgia, Christmas Eve, 1908; p. 45: Embossed and silvered, posted in Delaware, Ohio, 1908; p. 47: Posted in West Hoboken, N.J., Christmas Eve, 1910; p. 48: Embossed and made in U.S., posted in Minnesota, 1924; p. 50: Embossed, International Art Publishing Co., New York & Berlin; p. 51: Embossed and printed in U.S., posted in Winthrop, Me., Christmas Eve, 1909; p: 54: Gibson Art. Co., Cincinnati; p: 57: Made in U.S.A.; p. 58: Embossed and gilded, made in the U.S.A.; p. 59: Embossed and gilded; p. 60: Printed in Germany; p. 61: Embossed, posted on Christmas Eve, 1910 in Jamaica Plain Station, Boston; p. 62: Embossed and sent to Wichita, Kansas, 1919; p. 63: Made in U.S., posted in Perth Amboy, New Jersey, 1922; Back Cover: Thomas Nast